*For everyone who has ever
truly dared to live a dream.*

XOXO

~T

Was it a vision or a waking dream?

Fled is that music—

Do I wake or sleep? —John Keats

Dream With Your Eyes Open

Created by
Tracy Porter

**Andrews McMeel
Publishing**

Kansas City

With writing by
Tracy Porter
and Deb Hernandez

Photography by
Katy Rowe
and Dale Stenten

ISBN: 0-7407-0160-6

Dream With Your Eyes Open

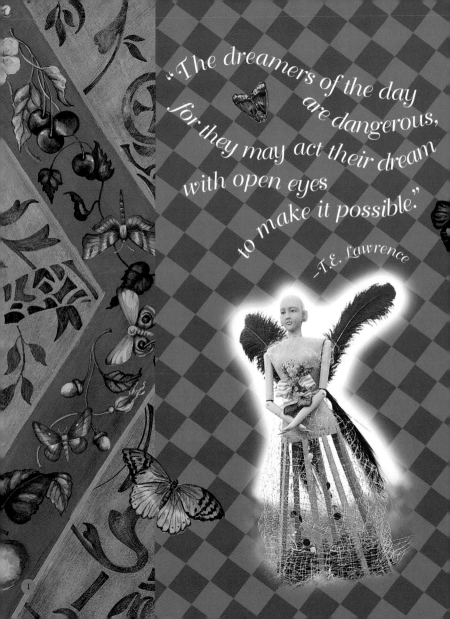

"The dreamers of the day are dangerous, for they may act their dream with open eyes to make it possible."

—T.E. Lawrence

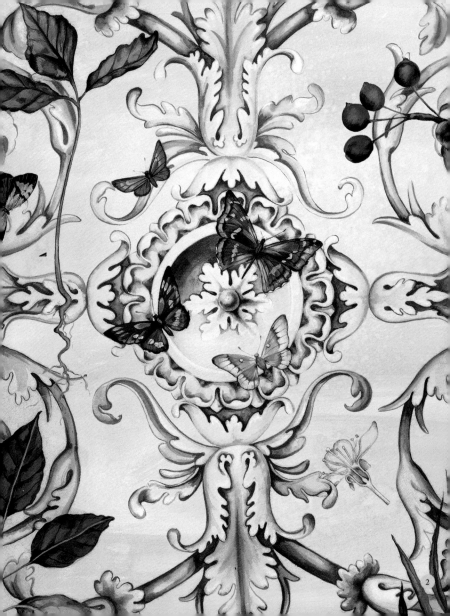

How to dream with your eyes open:

- *Believe in fantasy.*

- *Aspire to miracles.*

- *Experience magic.*

- *Savor the journey.*

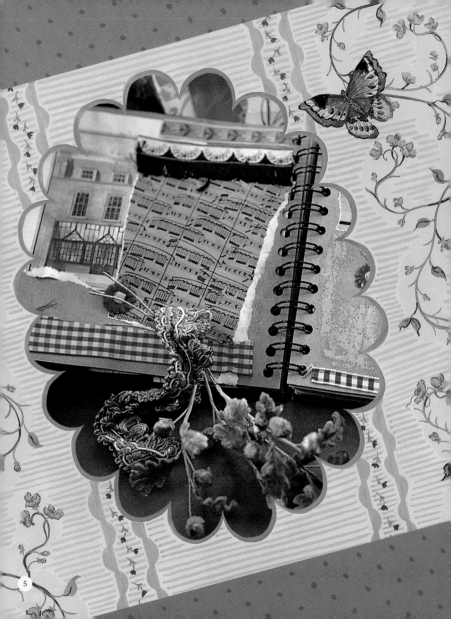

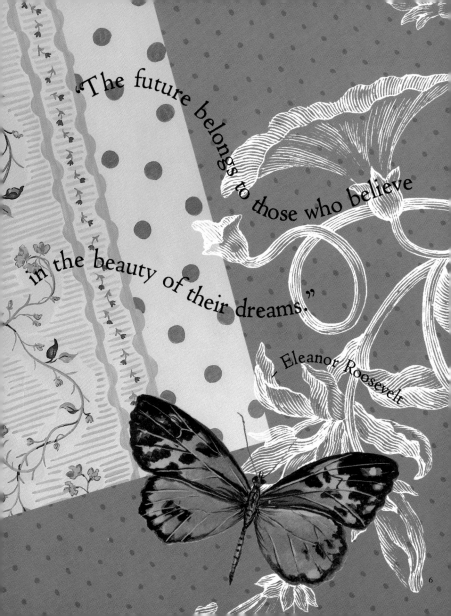

"The future belongs to those who believe in the beauty of their dreams."

— Eleanor Roosevelt

6

"Whatever
you can do
or dream you can,
begin it. Boldness has
genius, magic, and power in it.
Begin it now."

- Johann Wolfgang von Goethe

How do you pack
an open mind?

- Be willing to skin your knees.
- Embrace what it means to learn.
- Laugh often, especially in the face of adversity.
- Allow yourself the kindness of creativity.
- Find a new perspective.
- Break the rules.

"Make the most of yourself, for that is all there is of you."

— Ralph Waldo Emerson

"We all have strengths.
Know yours
and share them
as often as you can."

~Tracy Porter

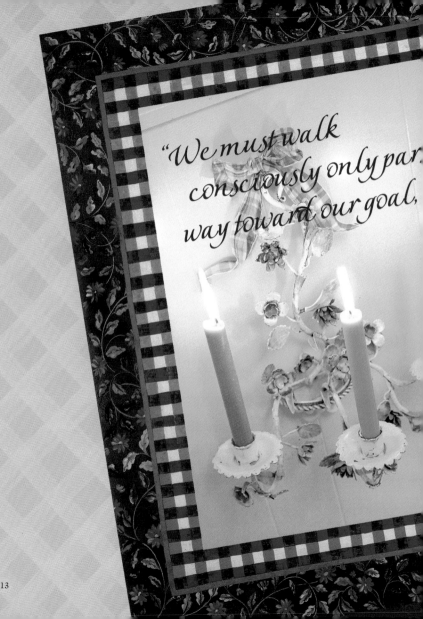

"We must walk
consciously only par...
way toward our goal,

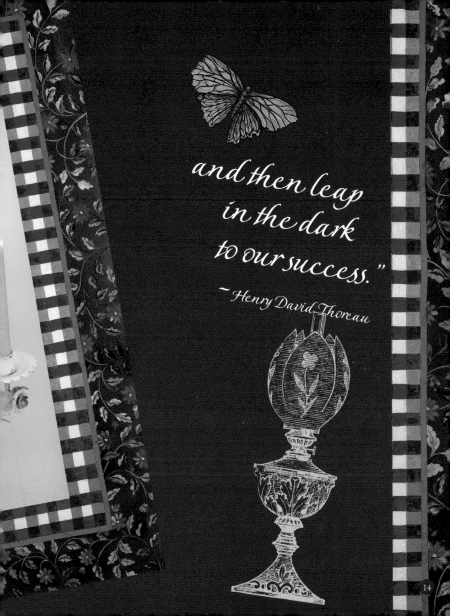

and then leap in the dark to our success."

~ Henry David Thoreau

Encourage your dreams...

- When your mind is awake.

- When you travel –
 distance changes
 your perspective.

- While smelling flowers.

By wearing a costume.

• While wearing your rose-colored glasses. (If you don't have a pair, it's time to get them!)

• When drinking pink lemonade.

- *While closing your eyes and remembering how it felt to skip as a child.*

- *While a dog is snoozing in your lap.*

- *In front of a fire's warm glow.*

With a friend (preferably one with a sense of humor).

- While listening to brilliant music.

- By indulging yourself in food you've never tasted.

"Jumpstart
yourself.

Don't wait for
someone else's push."

~ Tracy Porter

"Dare to be wrong and to dream."

—Friedrich von Schiller

"Make voyages. Attempt them. There's nothing else."

— Tennessee Williams

"No one can
lay a hand
on our dreams."

— E. V. Lucas

*To accomplish
great things,
we must not only act,
but also dream;
not only plan,
but also believe."*

— Anatole France

"A day can never
be filled with
too many
beautiful
thoughts."

Tracy Porter

Tracy Porter's Philosophies

- Get more of what you love into your every day.

- Try something new.

- Let your passions drive you!

- Get out of your comfort zone.

- Embrace the idea of change.

- Find your own voice.

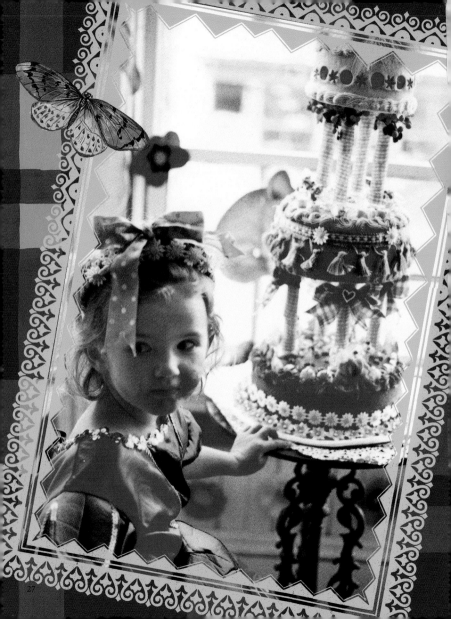

- Call a friend and share a memory.

- Play every day!

- Surround yourself with loveliness.

- Embrace the sweetness of life.

- Go somewhere and explore.

- Don't forget to dance.

"Go confidently in the direction of your dreams.

Live the life you have imagined."

— Henry David Thoreau

"It may be that those who do most, dream most."

– Stephen Leacock

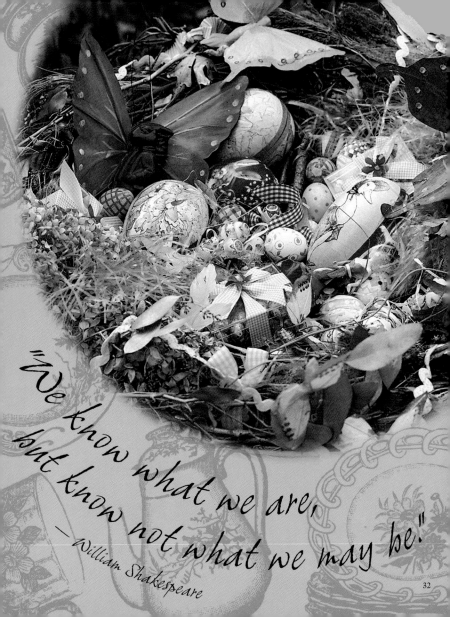

"We know what we are,
but know not what we may be."

— William Shakespeare

32

"There is
no rule book
on life."

~ Tracy Porter

"We grow great
by dreams."

– Woodrow Wilson

"Dreams are the touchstones of our character."

—Henry David Thoreau

"If you do not think
about the future,
you cannot
have one."

– John Galsworthy

36

Go Somewhere and Explore!

It is true that when we are young, we possess a fearless quality. I'm not sure why, but as we get older we have to remind ourselves more often that stepping outside of our comfort zone is a very healthy thing to do.

At 18, I decided to move to Paris. While my dearest friends were packing their parents' cars for the drive to college, I was boarding a plane to the most beautiful city in the world.

It was during my travels that I learned that opening yourself to new worlds is a way to embrace the unknown. I kept my rose-colored glasses on for the two years I lived in France, and this period continues to indulge me with my most significant muse.

~ Tracy Porter

"If a little dreaming
is dangerous, the cure
for it is not to dream less
but to dream more,
to dream all the time."

— Marcel Proust

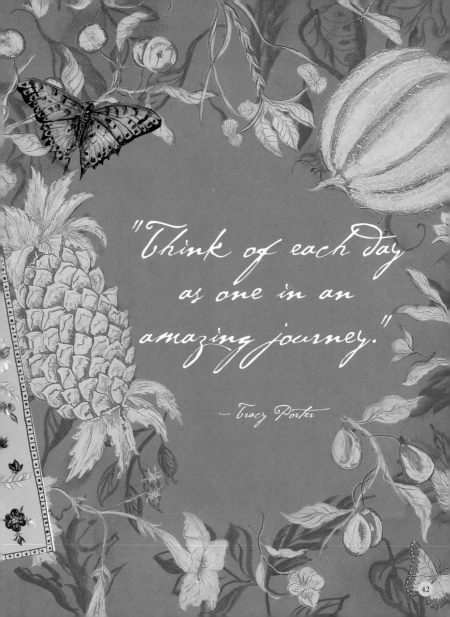

"Think of each day
as one in an
amazing journey."

— Tracy Porter

42

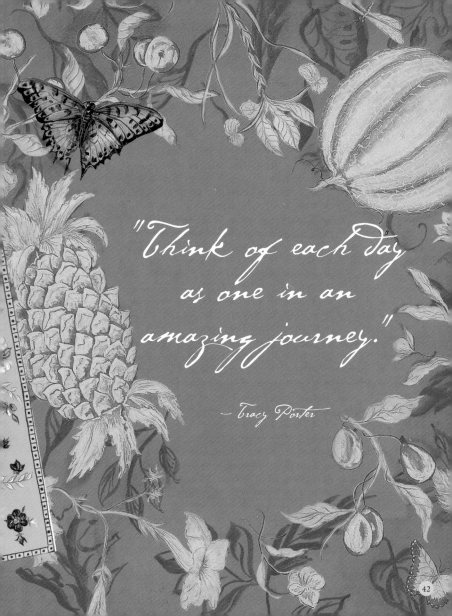

"Think of each day
as one in an
amazing journey."

— Tracy Porter